Lives of

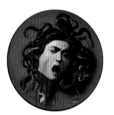

Caravaggio

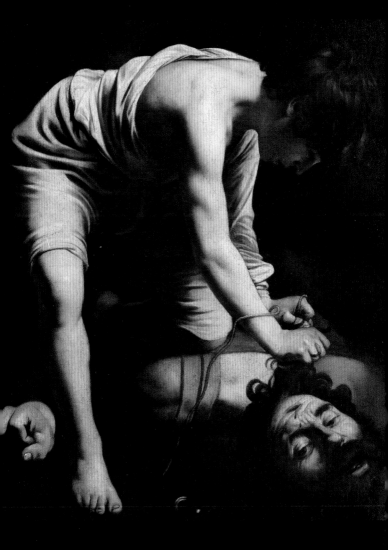

Lives of Caravaggio

Giulio Mancini

Giovanni Baglione

Giovanni Pietro Bellori

introduced by
Helen Langdon

The J. Paul Getty Museum, Los Angeles

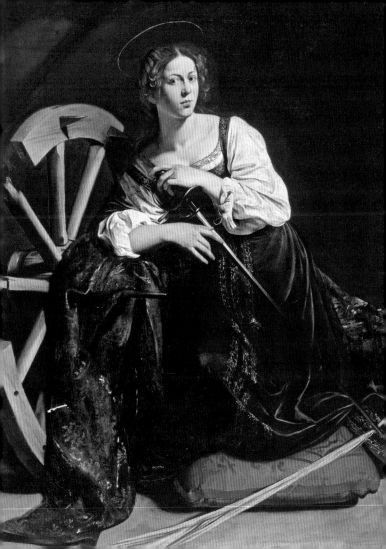

CONTENTS

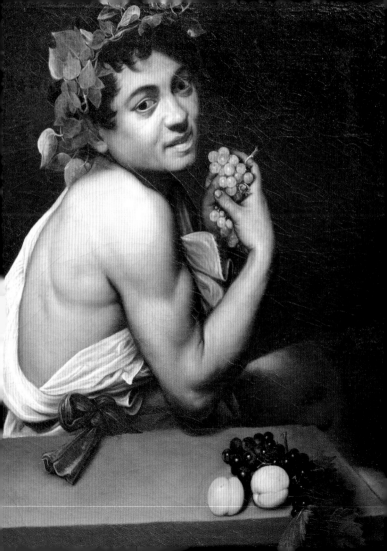

INTRODUCTION

HELEN LANGDON

In the summer of 1610 all Rome was awaiting the return of the painter Michelangelo da Caravaggio, who four years earlier had been banished and condemned to death for killing a man in a brawl. Now, pardoned by the Pope, he had left Naples for Rome; but his journey became a series of desperate misadventures, and, alone and destitute, the most celebrated painter in Italy died of a fever at the small fortress town of Port'Ercole, north of Rome. The news spread rapidly, and one correspondent reported the death of this 'famous painter…most excellent in colouring and imitation of nature'. His friend, the poet Giambattista Marino, honoured him as the creator of a spell-binding illusionism, feared by both death and nature. Nature, he writes,

> … was afraid
> Your hand would surpass it in every image
> You created, not painted….

Caravaggio's life had been stormy; his art had caused

Opposite: Self-portrait as Bacchus, c. 1593

passionate debate, and his belligerent nature and love of swordfighting often got him into trouble with the police. To contemporaries he seemed bizarre and unstable; vain, touchy and proud, he was feared as well as admired. And yet, as these epitaphs make clear, all were enthralled by the power of his almost magical naturalism; his art seemed, as the doctor and amateur of painting Francesco Scannelli wrote, to have 'attracted and ravished human sight'.

The vividness of contemporary debates over Caravaggio's revolutionary naturalism is clearly conveyed by the accounts of his life given in his early biographies. The first of these was written by Giulio Mancini, a Sienese physician, art historian and collector, and an important commentator on early 17th century taste in Roman painting. He had arrived in Rome in 1592; he knew the artist well in the period between 1595 and 1600, when he looked after him as a doctor, and his account of these early years is likely to be reliable. His taste was classicising, but he passionately admired Caravaggio, and saw clearly that the painter had breathed new life into a declining art in the last years of the 16th century. Second comes the account of Giovanni Baglione, mediocre painter and art historian, who was Caravaggio's rival in the intensely competitive art world of 17th century Rome, a world renowned for its bitter atmosphere

of envy and acrimony. Baglione was the first to imitate Caravaggio's style, and Caravaggio, notoriously jealous, attacked him in a series of outrageously scurrilous verses, provoking his competitor into sueing him for libel. Baglione deserves credit for his objectivity and his account has not been proven inaccurate; yet it is mean-spirited, and he seizes any opportunity to disparage the artist and to describe his misfortunes with ill-concealed pleasure. There followed a *Life* (1672) written by the antiquarian and theorist Giovanni Pietro Bellori. This is based on the two earlier sources, and Bellori's copy of Baglione, with his marginal notes, survives. Bellori's classicist belief that the artist should select the most beautiful parts of nature to create an 'idea' of perfect beauty dictated his assessment of Caravaggio's art. To him the most perfect combination of nature and art had been made by antique sculptors and by Raphael, and he disliked Caravaggio's excessive dependence on the model. Nonetheless Bellori appreciated his emotional power as a story teller, and it is in this *Life* that there are the most moving, precise and evocative descriptions of Caravaggio's paintings.

Michelangelo Merisi da Caravaggio was born in Caravaggio, a small town near Milan, in 1571; Baglione tells us that he was 'the son of a mason, quite well off', and recent archival research suggests that this is accurate. He was apprenticed in Milan to the Bergamese painter

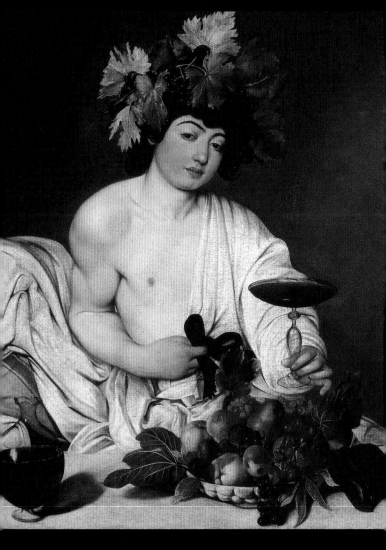

Simone Peterzano, and moved to Rome in 1592. Nothing is known about his art in Milan, though it seems likely that he specialised in portraits and still life. He came to Rome with no reputation and no money, and his first Roman years were harsh. The biographers give different and confusing accounts of these years, but together they suggest a young artist moving restlessly from studio to studio, carrying out humble tasks, but on the look-out for a rich protector. In this period, Roman art was idealising, and still haunted by the shade of Michelangelo, though there was the beginning of a new kind of naturalistic religious painting, clear and direct, and sweetly devotional. But Caravaggio painted genre paintings with half-length figures, often with prominent still lifes, such as the *Boy Bitten by a Lizard* (National Gallery, London, ill. p. 44) or *The Gypsy Fortune Teller* (Musei Capitolini, Rome, ill. overleaf); glowing with light and colour, topical and novel in subject, their naturalism and freshness, and their dependence on the model, delighted the Roman public. Something of the pleasure and wonder which they aroused is apparent in all the early sources. Still life was a new art form, and

Opposite: The Adolescent Bacchus, c. 1595

Overleaf: The Gypsy Fortune Teller, 1593

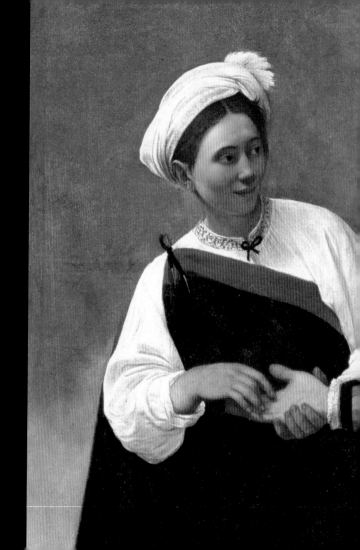

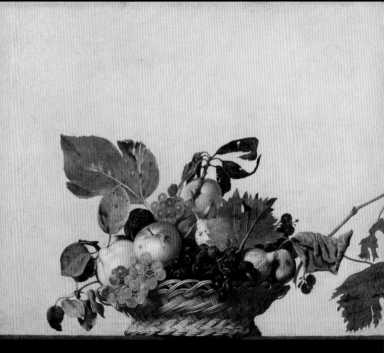

The Basket of Fruit, 1597-1600

his biographers marvel at Caravaggio's rendering of re-
flections in water and glass, and dewdrops sprinkled on
flowers, giving him credit as the creator of this genre.
Baglione praised the *Boy Bitten*, whom 'you could almost
hear… scream'; Mancini delighted in the 'graceful and
expressive figure of the gypsy'. Bellori, too, liked these
paintings, stressing their sweetness and directness, and
the freshness of their colour. (Bellori recognised that
the closest forerunners for Caravaggio's dreamy youths
lay in the art of Giorgione, and it is he alone who sug-
gests that Caravaggio visited Venice, which seems very
likely.) But to Bellori these were also polemical works,
manifestos for a naturalistic method of painting which
dangerously challenged the authority of Raphael and the
Antique. He tells us that Caravaggio poured scorn on
ancient sculptures, choosing nature alone as his model,
and to make his point took a street gypsy to his studio
and painted her there, predicting the future of a foppish
young man. And yet Caravaggio's gypsy is not a copy
of nature; clean and beautiful, elaborately dressed and
posed, with careful studio lighting, she creates a subtle
atmosphere of deceit; she was perhaps intended to dem-
onstrate the magical power of painting when it imitates
mere reality.

In the mid-1590s one of Caravaggio's genre scenes,
the *Card Sharps* (Kimbell Art Museum, Fort Worth, ill.

p. 69) caught the attention of a distinguished collector, Cardinal del Monte, and in the autumn of 1595 Caravaggio became a paid retainer in the Del Monte household in the Palazzo Madama. Over the next few years he painted gallery pictures both for the Cardinal and for an élite group of Roman collectors. But in 1599 Caravaggio won the commission for two lateral paintings, *The Calling of St Matthew* and *The Martyrdom of St Matthew,* for a chapel in the Roman church of San Luigi dei Francesi (in situ, ill. opposite and p. 77). This commission won him immense fame, and split the Roman art world into violently opposed camps. In these paintings he took the novel subjects of his genre scenes, the vivid characters of contemporary Roman streets, and turned them into religious art. Baglione says the paintings were done from life, and the dramatic contrasts of light and dark enhance the powerful illusionism. They represent an utter rejection of classical art, with its emphasis on idealised, timeless figures and on a universal language of gesture and expression. Young artists, entranced, took up his cause; but Baglione commented that the 'paintings were excessively praised by evil people' and reported the sneering comments of the leading academic painter, Federico Zuccaro. Mancini says little about these works,

Opposite: The Calling of St Matthew, 1599-1600

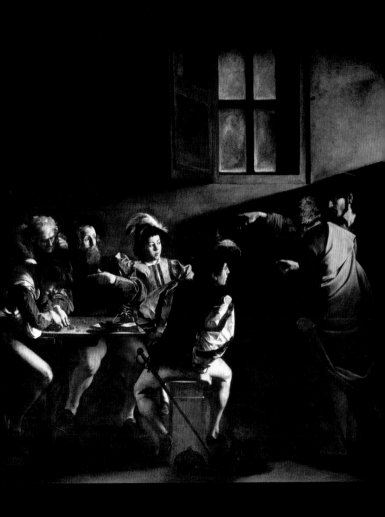

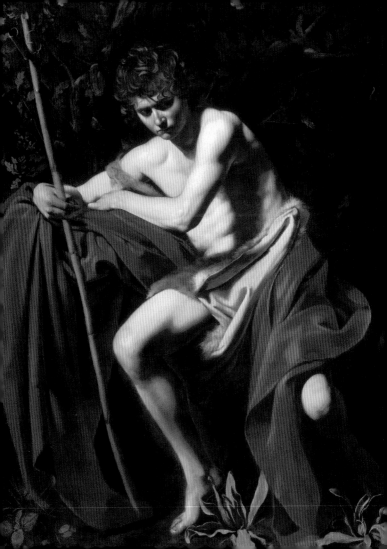

but he does condemn as unnatural the effects of Caravaggio's use of a single light source in a darkened room to enhance relief, and stresses the limitations of painting from the model. This, he says, may serve for single figures, but it is impossible to pose a multitude of people in a room to act out a story. Mancini's criticisms of Caravaggio's cellar light were taken up and elaborated by Bellori. For Bellori, Caravaggio was incapable of presenting action, and for him the painter's concentration on a single moment stripped his art of any universal significance.

Over the next six years Caravaggio painted a series of works for Roman churches which continued to cause controversy. A first version of an altarpiece of *St Matthew and the Angel* (destroyed; formerly Kaiser-Friedrich Museum, Berlin, ill. p. 74), with a burly, plebeian saint, legs crossed and bare feet thrust forward, was removed from the church, and, Baglione says, with obvious pleasure, it 'pleased nobody'; Bellori elaborates on this, stressing that the painting lacked decorum, and that the saint was insufficiently dignified. Modern scholars have questioned this story, suggesting that this and other reports of rejected paintings were motivated by malice. Yet all agree that the *Death of the Virgin* (Louvre, Paris;

Opposite: St John the Baptist in the Wilderness, 1604-5

ill. p. 52), which shows the Virgin as a working class woman with swollen belly, was indeed rejected; Mancini, who tried to buy the painting, states very clearly that this was because Caravaggio had here painted a dirty prostitute. *The Entombment of Christ* (Vatican Museum, ill. p. 78) was the most highly praised of these Roman works, and Baglione says that it was his best; significantly this is Caravaggio's most classical painting, clearly structured and composed, and with obvious debts to Raphael and to classical art.

In 1606 these years of fame and lively artistic debate came to an end; Caravaggio killed Ranuccio Tommassoni in a street fight, and was exiled from Rome. Baglione, who probably knew him, calls Ranuccio 'a very polite young man' and claims that the two fell out over a tennis match. In fact Ranuccio was the leader of a rowdy gang of street fighters, and the fight, perhaps over a woman, seems to have been the culmination of a series of minor incidents. The tennis match may have served as cover for a planned fight, with four men on each side, and it finished with Caravaggio ignominiously stabbing Ranuccio as he fell. All the participants were banished, and Caravaggio was condemned to death. He fled to the Alban Hills, where the powerful Colonna family protected him.

The last four years of his life, ending with his lonely death in Port'Ercole, read like an adventure story;

Caravaggio, a bandit yet a celebrity, on the run and yet sought after, moved from Naples, where his art was already prized, and on to Malta, probably obsessed by the dream of becoming a Knight of Malta. Here, admired by the Grand Master, Alof de Wignacourt, he fulfilled this dream, but was almost immediately imprisoned and defrocked. Both Baglione and Bellori tell us that he was imprisoned because of a brawl, and new archival research has confirmed this simple explanation. Imprisoned in a deep undergound cell, he executed a daring night-time escape with a rope ladder, fleeing across the turbulent sea to Sicily. Here he hastened from city to city, his works in great demand, finally returning to Naples before his ill-fated journey to Rome. Neither Mancini nor Baglione mention any of the paintings from these late years (Mancini does not mention Sicily at all), but Bellori gives a remarkably full account of the most famous works from each place. It is to him that we owe the first description of the urgent and powerful technique of the late works, of how, in *The Beheading of St John the Baptist* (Oratory of the Co-Cathedral of St John, Valletta, ill. overleaf), 'Caravaggio put all the force of his brush to use, working with such intensity that he let the priming of the canvas show through the half-tones'.

Overleaf: The Beheading of St John the Baptist, 1607

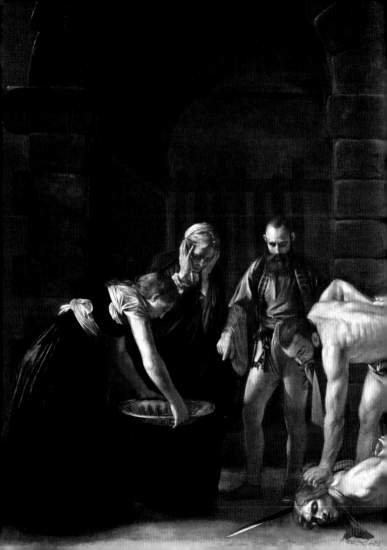

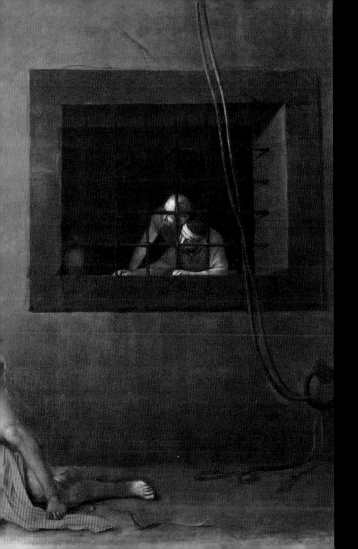

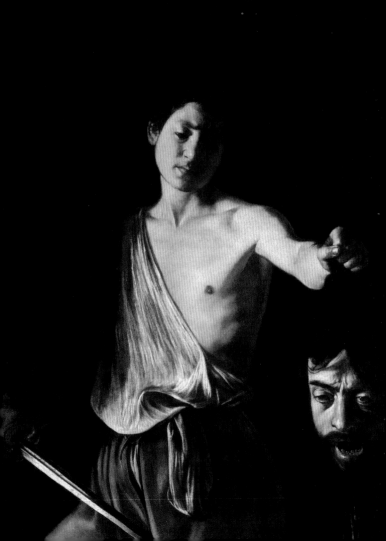

Both Baglione and Bellori convey Caravaggio's desperate sense of persecution, Bellori, in a memorable phrase, stating that 'fear hunted him from place to place'. Baglione tells us that Caravaggio was wounded and scarred in Naples, and news of this disfigurement was swift to reach Rome; Mancini, ever anxious for Caravaggio's return, wrote in alarm to his brother, 'If this is true it is a sin, and deeply disturbing...'. In his *David with the Head of Goliath* (Galleria Borghese, Rome, ill. opposite) Caravaggio painted himself as the head of Goliath, and perhaps this ravaged and scarred face was inspired by this attack in Naples. A recently discovered series of letters from the Bishop of Caserta to Scipione Borghese, papal nephew and patron of Caravaggio, has confirmed the early biographers' account of Caravaggio's death from a fever at Port'Ercole, probably in the local infirmary. On the journey to Rome the artist had been imprisoned, and on his release had followed the felucca north to this fortress town, desperately hoping to retrieve paintings intended as a placatory gift for Scipione.

All three writers attempted an assessment of Caravaggio's art and life. In the 17th century, history painting, the painting of noble scenes from literature or the Bible in which the artist displayed his skill in the handling of the

Opposite: David with the Head of Goliath, c.1609-10

human figure, of space, and of *invenzione* (invention), was held to be the highest form of art, and it is in this context that these assessments should be read. In Baglione's account, followed by Bellori, there is a kind of fear that Caravaggio's insistence on painting from the model, and his tendency to arrange a few figures in a shallow foreground, destroyed the noble skills of drawing and composition which academic painters acquired through long study. It was moreover an easy style, dangerously attractive to the young, who began to delight in painting 'common and vulgar things', in recording 'wrinkles, … knotted fingers and limbs disfigured by disease' (Bellori). With Baglione this standpoint is sharpened by an intensely personal dislike of Caravaggio's boasting and vanity and by envy of his high fees; these, he believed, were due to Caravaggio's gang of supporters and to his celebrity status, so that people, as he nicely puts it, judged not with their eyes, but looked with their ears. Bellori, less involved, was more generous; he praised Caravaggio's colour, and acknowledged the need, in the late 16th century, for art to renew its contact with nature. His eloquent descriptions of such works as *The Taking of Christ in the Garden* (National Gallery of Ireland, Dublin, ill. pp. 82-83) suggest how deeply he responded to the works.

The dangerous subversiveness of Caravaggio's art

is connected by each writer to his disturbed character and all condemn him morally. Mancini claimed that his oddities both shortened his life and diminished his fame; Baglione concluded the dramatic account of his death with the acid remark —'without the aid of God or man, … he died, as miserably as he had lived'. Bellori elaborated on these remarks, adding new anecdotes about Caravaggio's deplorable failure to wash or change his clothes. He also believed that Caravaggio's dark style corresponded to his dark appearance, to his black hair and dark eyes; his temperament too was dark and disturbed, and connected to his dark style.

Bellori makes the simplest of connections between art and life, but it has remained difficult not to make some kind of connection. Caravaggio's works include several self-portraits, which move from confidence to the despair of the head of Goliath; the late works, many of executioners and their victims, do seem to convey a tragic contemplation of death and human evil. And in the 20th century the moral failings condemned by his early biographers became virtues; Caravaggio, failure, bohemian, outsider, rebel, violent, became the prototype of an ideal 20th century artist. In recent years art historians have established how facile is the belief that Caravaggio simply painted what was before him, and how deep and complex was his relationship to the art of the past; they

have debated whether Caravaggio was indeed a rebel with libertine beliefs, or whether his art is deeply rooted in the spirituality of the Counter Reformation church. But the life itself has in a sense taken on an independent existence, in a wealth of films, novels, plays and poems, and, separated from the works, and from any contemporary context, it has become a powerful modern myth.

GIULIO MANCINI

On Michelangelo Merisi da Caravaggio

from

Considerazioni sulla pittura

c. 1617-21

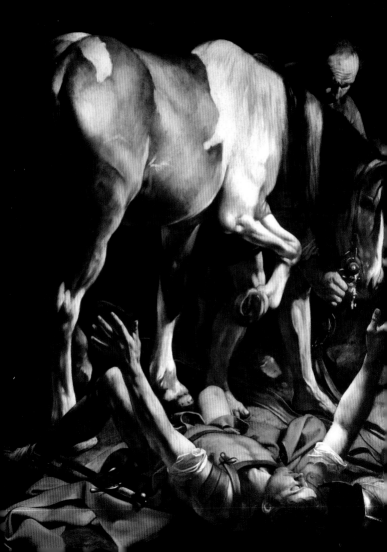

Our times owe much to Michelangelo da Caravaggio for the method of painting he introduced, which is now quite widely followed.

He was born in Caravaggio of honourable citizens since his father was majordomo and architect to the Marchese of Caravaggio. At a young age he studied diligently for four to six years in Milan, though now and then he would do some outrageous thing because of his hot nature and high spirits.

At the age of about twenty he moved to Rome where, since he had no money, he lived with Pandolfo Pucci from Recanati, a beneficiary of Saint Peter's, because he was able to work from his room by doing unpleasant work. Worse, he was given nothing but salad to eat in the evening, which served as appetizer, entrée and dessert — as the corporal says, as accompaniment and tooth-pick. After a few months he left with little recompense, calling his benefactor and master 'Monsignor Salad'.

During his stay he painted some copies of devotional images that are now in Recanati.[1] He painted for sale a boy who cries out because he is bitten by a

1. Lost

Opposite: The Conversion of St Paul, 1600-1601

lizard that he holds in his hand,[1] and then he painted another boy who is peeling a pear with a knife,[2] and a portrait of an innkeeper who had given him lodgings[3] and the portrait of [text missing here].

In the meantime he was struck by sickness and, being without money, was obliged to enter the hospital of the Consolazione, where during his convalescence he made many pictures for the prior, who brought them to Seville, his home.[4]

Afterward, I have been told, he stayed with Cavaliere Giuseppe [Cesari d'Arpino] and Monsignor Fatin Petrigiani, who gave him the comfort of a room in which to live. During that period he painted many pictures, and in particular a Gypsy who tells a young man his fortune,[5] the Flight into Egypt,[6] The Penitent Magdalen,[7] a St John the Evangelist.[8]

These were followed by the Deposition of Christ[9] in the Chiesa Nuova; the pictures in San Luigi,[10] the

1. Versions in the National Gallery, London, and private collection, Florence, the latter ill. p. 44 2. *c.* 1593, original lost, several copies in private collections 3. Lost 4. Lost 5. 1593, Musei Capitolini, Rome, ill. pp. 12-13. Another autograph version in the Louvre is probably later 6. *c.* 1597, Galleria Doria-Pamphilj, Rome, ill. opposite 7. *c.* 1597, Galleria Doria-Pamphilj, Rome, ill. p. 67 8. Lost 9. Probably the *Entombment*, 1602-3, Vatican Museums 10. *The Calling of St Matthew, The Martyrdom of St Matthew*, both 1599-1600, *St Matthew and the Angel*, 1602, all in situ, ill. pp. 17, 77, 75 respectively

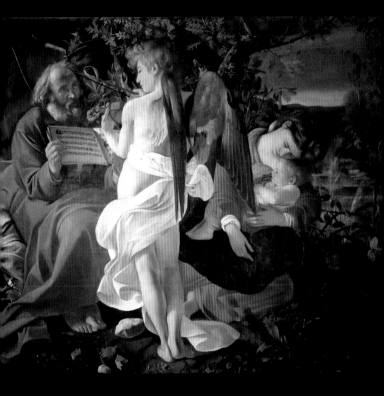

Rest on the Flight into Egypt,
c. 1597

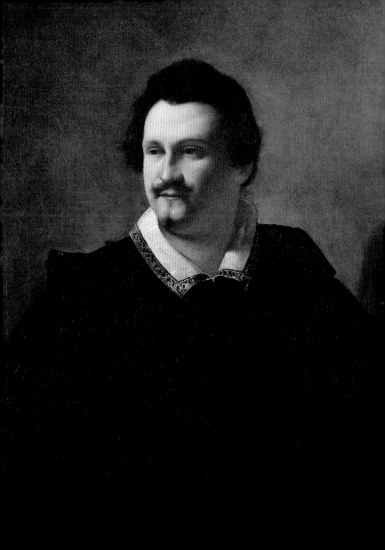

Death of the Virgin[1] for Santa Maria della Scala, which the Duke of Mantua now has since the fathers of that church had it removed because Caravaggio portrayed a courtesan as the Virgin; the Madonna of Loreto[2] in Sant'Agostino; and the Madonna for the altar of the Palafrenieri in Saint Peter's.[3] He also did many paintings now owned by the most illustrious [Cardinal Scipione] Borghese, the Cerasi Chapel in Santa Maria del Popolo,[4] and many paintings privately owned by the Mattei, the Giustiniani, and the Sannesio.

Finally, as a result of certain events, he almost lost his life, and in defending himself Caravaggio killed his foe with the help of his friend Onorio Longhi and was forced to leave Rome. He first reached Zagarolo where he was secretly housed by the prince. There he painted a Magdalen[5] and a Christ going to Emmaus,[6] which was bought by Costa in Rome.

1. 1602-5, Louvre, Paris, ill. p. 52 2. 1604-5, in situ, ill. p. 51 3. 1605-6, Galleria Borghese, Rome 4. *Conversion of St Paul, Martyrdom of St Peter,* 1600-1601, in situ, former ill. p. 30 5. Possibly identifiable with a painting in a private collection, Rome; also known in a copy by Louis Finson, Musée des Beaux-Arts, Marseilles 6. Probably the painting in the Brera, Milan, 1605-6, ill. overleaf

Opposite: Portrait of a Gentleman, 1598-1604. Possibly Scipione Borghese

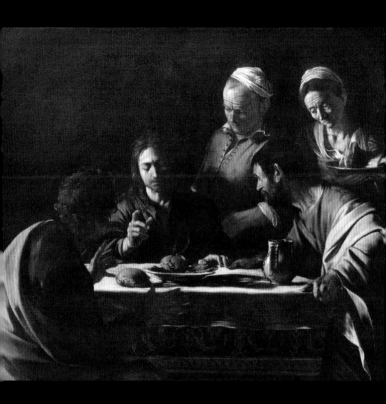

Christ going to Emmaus, 1605-6

With these earnings he moved on to Naples, where he painted various works.

From there he went on to Malta, where he did some paintings that pleased the Grand Master, who as a token of his appreciation (it is said) gave him the Cloak of his Order. Caravaggio left Malta with the hope of being pardoned, but at Port'Ercole he was stricken by a malignant fever and there, between thirty-five and forty years of age, at the height of his success, he died of privation without any help, and was buried nearby.

It cannot be denied that for single figures, heads, and colouring he attained a high point, and that the artists of our century are much indebted to him. But greater knowledge of art went together with extravagance of behaviour. Caravaggio had an only brother, a priest, a man of letters and of high morals who, when he heard of his brother's fame, wanted to see him and, filled with brotherly love, arrived in Rome. He knew that his brother was staying with Cardinal Del Monte, and being aware of his brother's eccentricities, he thought it best to speak first to the Cardinal, and explain everything to him, which he did. He was well received by the Cardinal, who asked him to return in three days. He did so. In the meantime, the Cardinal called Michelangelo and asked him

if he had any relatives; he answered that he did not. Unwilling to believe that the priest would tell him a lie about a matter that could not be checked, and that would do him no good, he asked among Caravaggio's compatriots whether he had any brothers, and who they were, and so discovered it was Caravaggio who had lied. After three days the priest returned and was received by the Cardinal, who sent for Michelangelo. At the sight of his brother he declared that he did not know him and that he was not his brother. So, in the presence of the Cardinal, the poor priest said tenderly: 'Brother, I have come from far away to see you, and thus I have fulfilled my desire; as you know, in my situation, thank God, I do not need you for myself or for my children, but rather for your own children if God will give you the blessing of marriage and see to your succession. I hope God will do you good as I will pray to His Divine Majesty during my services, as will be done by your sister in her virginal and chaste prayers.' But Michelangelo was not moved by his brother's ardent and stimulating words of love, and so the good priest left without even a goodbye. Thus one cannot deny that Caravaggio was a very odd person, and that his eccentricities served to shorten his life by at least ten years and somewhat diminished the fame he had acquired through his profession. Had he lived

longer he would have grown, to the great benefit of students of art.

…when a poor painter needs to sell a picture at a lower price than he had done in previous times, he loses his reputation, as indeed Caravaggio did when he sold the Boy Bitten by a Lizard for fifteen guili, and the Gypsy for eight scudi….

Before going further, we must consider the aspects of the figures in order that they look appropriate, with expression and movement such as will portray a person in a particular activity. As a result we can comprehend how poorly some modern artists paint. For example, when they wish to portray the Virgin Our Lady they depict some dirty prostitute from the Ortaccio, as Michelangelo da Caravaggio did when he portrayed the Death of the Virgin in the picture of the Madonna della Scala, which the good Fathers rejected for that reason and perhaps consequently Caravaggio suffered so much trouble during his lifetime…

…now that we have reached the century of living artists, I should like to propose the following ideas in order to examine them, namely:

That these living painters be divided into four categories or classes, or better, schools, one of which is that of Caravaggio, which had a wide following taken up with vigour and knowledge by Bartolomeo Manfredi, Spagnoletto [Giuseppe Ribera], Francesco, also called Cecco, del Caravaggio, Spadarino [Giacomo Galli], and partially by Carlo [Saraceni] Veneziano. A characteristic of this school is lighting from one source only, which beams down without reflections, as would occur in a very dark room with one window and the walls painted black, and thus with the light very strong and the shadows very deep, they give powerful relief to painting, but in an unnatural way, something that was never thought of or done before by any other painter like Raphael, Titian, Correggio, or others. This school, working in this way, is closely tied to nature, which is always before their eyes as they work. It succeeds well with one figure alone, but in narrative compositions and in the interpretation of feelings, which are based on imagination and not direct observation of things, mere copying does not seem to me to be satisfactory since it is impossible to put in one room a multitude of people acting out the story, with that light coming in from a single window, having to laugh or cry or pretending to walk while having to stay still in order

to be copied. As a result the figures, though they look forceful, lack movement, expression, and grace, as is the case with this style, as we shall see. Of this school I do not think that I have seen a more graceful and expressive figure than that Gypsy who tells good fortune to a young man, by Caravaggio, a picture owned by Signor Alessandro Vittrici, a gentleman of Rome. Here too, while using the same method, nonetheless he shows the Gypsy's slyness with a false smile as she takes the ring of the young man, who shows his naïveté and the effects of his amorous response to the beauty of the little Gypsy who tells his fortune and steals his ring.

[The four schools of painters]

In the present century there followed the most modern painters, who it seems to me achieved perfection through intelligence, style, and force of colouring, in landscapes and in perspectives. Our century can be divided into four schools that represent four different styles of painting.

The first should be the Carraci. …

The second school is that of Michelangelo da Caravaggio, which is forceful and excellently

coloured. There are many works by him: the Deposition from the Cross in the Chiesa Nuovo, the Madonna dell' Orto in Sant'Agostino, the chapel of St Matthew in the church of San Luigi dei Francesi, and many privately owned pictures, and particular those in the house of Marchese Giustiniani and of Alessandro Vittrici; on the right side of the church of the Madonna della Scala, and in Monte Cavallo there are many things in the room before the chapel,* and many other pictures in private houses. In this century it has been taken up and followed by many, and its characteristic is a certain naturalness.

The third school is that of Cavaliere Giuseppe Cesari....

* Here Mancini seems to be talking of paintings by Caravaggio's followers.

GIOVANNI BAGLIONE

The Life of
Michelangelo da Caravaggio,
Painter

from

Le vite de' pittori, scultori et architetti

1642

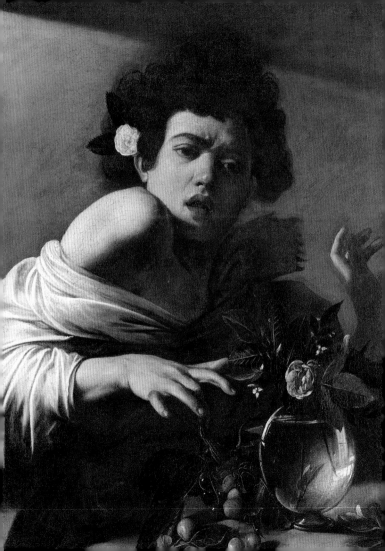

Michelangelo, born in Caravaggio in Lombardy, was the son of a mason, quite well off, of the Merisi family. He decided to study painting and, because nobody was competent to teach him in Caravaggio, he moved to Milan and remained there for some time. Subsequently he went to Rome with the desire of learning this admirable discipline with diligence. In the beginning he settled down with a Sicilian painter who had a shop full of crude works of art.

Then he moved into the house of Cavaliere Giuseppe Cesari d'Arpino for a few months. From there he tried to live by himself, and he painted some portraits of himself in the mirror. The first was a Bacchus with different bunches of grapes, painted with great care though a bit dry in style.[1] He also painted a boy bitten by a lizard emerging from flowers and fruits:[2] you could almost hear the boy scream, and it was all done meticulously.

Nevertheless he was unable to sell these works, and

1. *c.* 1593, Galleria Borghese, Rome, ill. p. 6 2. *c.* 1595, National Gallery, London, and private collection, Florence: there is controversy over which is the prime version; London version ill. opposite

Opposite: Boy Bitten by a Lizard, c. 1595

in a short time he found himself without money and poorly dressed. But some charitable gentlemen expert in the profession came to his aid, and finally Maestro Valentino, a dealer in paintings at San Luigi dei Francesi, managed to sell a few. This was the means by which he met Cardinal Del Monte, an art lover, who invited him to his home. In these quarters Michelangelo was given room and board, and soon he felt stimulated and confident. For Cardinal Del Monte he painted a Concert of Youths from nature,[1] very well. He also painted a youth playing a lute,[2] and everything seemed lively and real, such as the carafe of flowers filled with water, in which we see clearly the reflection of a window and other objects in the room, while on the petals of the flowers there are dewdrops imitated most exquisitely. And this picture (he said) was the best he had ever done.

He portrayed a Gypsy predicting the future to a young man, with beautiful colours.[3] He painted a Divine Love who subjugated the Profane.[4] Similarly, he made a head of a terrifying Medusa, with vipers

1. *c.* 1595, Metropolitan Museum of Art, New York, ill. opposite 2. *c.* 1596, Hermitage, Saint Petersburg 3. Either the painting of 1593 in the Musei Capitolini, Rome, ill. pp. 12-13, or the later version in the Louvre, Paris 4. Lost

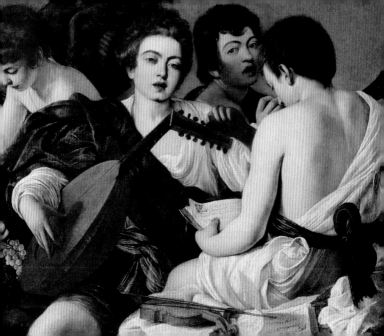

for hair, placed on a shield,[1] which the Cardinal sent as a gift to Ferdinando, Grand Duke of Tuscany.

With the support of his Cardinal he got the commission for the Contarelli Chapel in San Luigi dei Francesi, where over the altar he painted Saint Matthew with an angel.[2] On the right side, the Calling of the Apostle by the Saviour,[3] and on the left the Saint is shown at the altar, wounded by the executioner, with other figures.[4] The vault of the chapel, however, is quite well painted by Cavaliere Giuseppe Cesari d'Arpino.

This commission with the paintings done after life, together with those of Cavaliere Giuseppe, whose talent aroused a certain envy on the part of his colleagues, made Caravaggio famous, and the paintings were excessively praised by evil people. When Federico Zuccaro came to see this picture, while I was there, he exclaimed: 'What is all the fuss about?' and after having studied the entire work carefully, added: 'I do not see anything here other than the style of Giorgione in the picture of the Saint when Christ calls him to the Apostolate'; and, sneering, astonished by such commotion, he turned his back

1. 1597, Uffizi, Florence, ill. p. 1 2. 1602, in situ 3. 1599-1600, in situ; ill. p. 17 4. 1599-1600, in situ, ill.p. 77

and left. For Marchese Vincente Giustiniani he did a seated Cupid from life,[1] so exquisitely painted that thereafter Giustiniani admired Caravaggio beyond reason; and a certain picture of St Matthew, that he had first made for that altar in San Luigi,[2] which pleased nobody, but because it was by Michelangelo, Giustiniani took it for himself. The Marchese had been put into this frame of mind as a result of the propaganda by Prosperino delle Grottesche, Caravaggio's henchman, who was hostile toward Cavaliere Giuseppe. Moreover, Signor Ciriaco Mattei succumbed to the propaganda: for him Caravaggio had painted St John the Baptist,[3] the Lord going to Emmaus,[4] and also St Thomas who pokes his finger into the ribs of the Saviour.[5] Thus Caravaggio pocketed many hundred scudi from this gentleman.

In the first chapel on the left in the church of Sant' Agostino, he painted the Madonna of Loreto from life with two pilgrims; one of them has muddy feet and the other wears a soiled and torn cap; and

1. c. 1602, Gemäldegalerie, Berlin, ill. p. 80 2. 1602, destroyed; formerly Kaiser-Friedrich Museum, Berlin, ill. p. 74 3. 1602, Musei Capitolini, Rome, ill. p. 70 4. 1601-2, London, National Gallery 5. c. 1603, Staatliche Schlösser & Gärten, Potsdam

because of this pettiness in the details of a grand painting the public made a great fuss over it.[1]

In Santa Maria del Popolo on the right side of the high altar, in the chapel of the Cerasi family, above on the wall there are his Crucifixion of St Peter and on the opposite side the Conversion of St Paul. At first these two pictures had been painted in a different style, but because they did not please the patron, Cardinal Sannesio took them; in their place he painted the two oil paintings that can be seen there today,[2] since he did not use any other medium. And — so to speak — Fortune and Fame carried him along.

In the Chiesa Nuova, on the right side in the second chapel, is his oil painting of the Dead Christ[3] who is about to be buried, with other figures; and this work is said to be his best.

For Saint Peter's in the Vatican, a St Anne with the Madonna shows the Virgin holding the Child between her legs, with the foot crushing the serpent's head.[4] This work was painted for the Grooms of the

1. 1604-5, in situ, ill. opposite 2. 1600-1601, in situ. The first version of the *Crucifixion of St Peter* is lost, but the first *Conversion of St Paul* survives in the Odescalchi collection, Rome; the second version is ill. p. 30 3. Probably 1602-3, Vatican Museum, ill. p. 78 4. 1605-6, Galleria Borghese, Rome, ill. p. 102

Opposite: The Madonna of Loreto, 1604-5

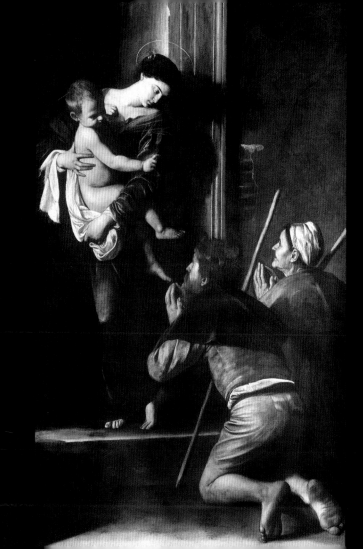

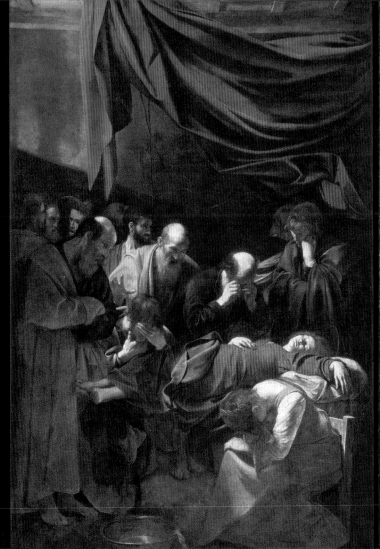

Palace, but it was removed on the orders of the Cardinals in charge of Saint Peter's and subsequently given by the Palafrenieri to Cardinal Scipione Borghese.

For the Madonna della Scala in Trastevere Caravaggio painted the Death of the Virgin,[1] but because he had portrayed the Virgin with little decorum, swollen, and with bare legs, it was taken away; and the Duke of Mantua bought it and placed it in his noble Gallery.

For the Signori Costa he made a Judith who cuts off the head of Holofernes,[2] and other pictures which I omit because they are not in public places, and instead I will discuss something about his habits.

Michelangelo Merisi was a satirical and proud man; at times he would speak badly of the painters of the past, and also of the present, no matter how distinguished they were, because he thought that he alone had surpassed all the other artists in his profession. Moreover, some people thought that he had

1. 1602-5, Louvre, Paris, ill. opposite 2. c. 1599, Galleria Nazionale d'Arte Antica, Rome, ill. overleaf

Opposite: Death of the Virgin, 1602-5

Overleaf: Judith beheading Holofernes, c. 1599

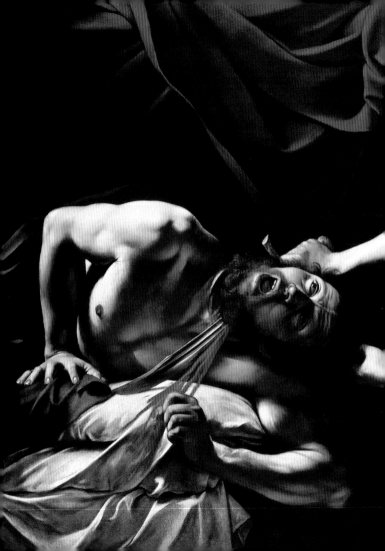

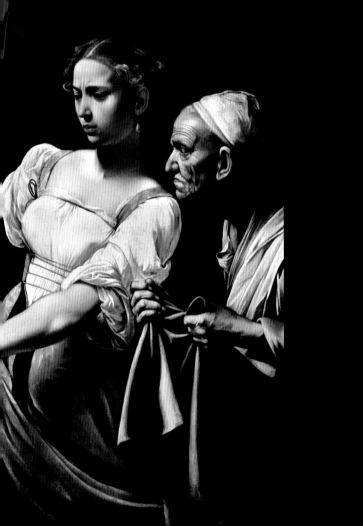

destroyed the art of painting; also, many young artists followed his example and painted heads from life, without studying the rudiments of design and the profundity of art, but were satisfied only with the colours; therefore these painters were not able to put two figures together, nor could they illustrate a history because they did not comprehend the value of so noble an art.

Because of his excessively fearless nature Michelangelo was quite a quarrelsome individual, and sometimes he looked for a chance to break his neck or jeopardize the life of another. Often he was found in the company of men who, like himself, were also belligerent. And finally he confronted Ranuccio Tomassoni, a very polite young man, over some disagreement about a tennis match. They argued and ended up fighting, Ranuccio fell to the ground, and Michelangelo stabbed him and gave him a fatal wound in the upper thigh. Everyone who was involved in this affair fled Rome and Michelangelo too went to Palestrina, where he painted a Mary Magdalen.[1] From there he moved to Naples, where he also produced many paintings.

1. Possibly identifiable with a painting in a private collection, Rome; also known by a copy by Louis Finson, Musée des Beaux-Arts, Marseilles

Then he went to Malta, where he was invited to pay his respects to the Grand Master and to make his portrait.[1] Whereupon this Prince, as a sign of gratitude, presented him with the Mantle of St John and made him a Cavaliere di Grazia. Here, following some sort of disagreement with the Cavaliere di Giustizia, Michelangelo was put into prison. But he managed to escape at night by means of a rope ladder and fled to the island of Sicily. In Palermo he painted some works. But since his enemies were chasing him, he decided to return to Naples. There they finally caught up with him, wounding him on his face with such severe slashes that he was almost unrecognizable. Despairing of revenge for this vicious act and with all the agony he had experienced, he packed his few belongings and boarded a little boat in order to go to Rome, where Cardinal Gonzaga was negotiating with Pope Paul V for his pardon. On the beach where he arrived, he was mistakenly captured and held for two days in prison and when he was released, his boat was no longer to be found. This made him furious, and in desperation he started out along the beach under the heat of the July sun, trying to catch

1. *c.* 1608, Louvre, Paris, ill. p. 92

Overleaf: The Denial of St Peter, 1610

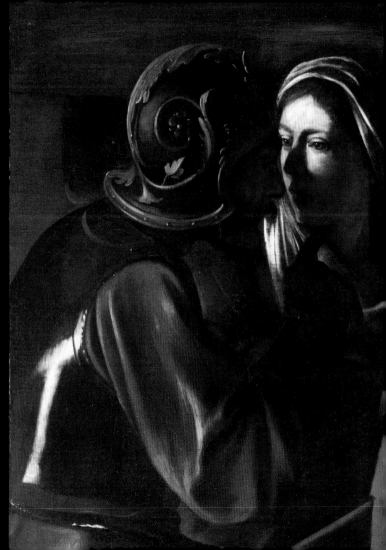

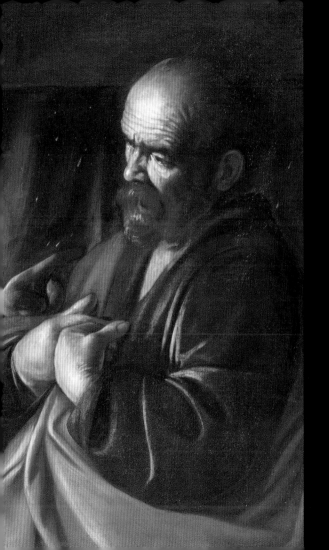

sight of the vessel that had his belongings. Finally, he came to a place where he was put to bed with a raging fever; and so, without the aid of God or man, in a few days he died, as miserably as he had lived.

If Michelangelo Merisi had not died so soon, the art world would have profited greatly from his beautiful style, which consisted of painting from nature; although in his pictures he did not have much judgment in selecting the good and avoiding the bad, he nevertheless was able to earn great credit for himself, and he was paid more for his portraits, such is the value of recognition by the people, who judge not with their eyes but look with their ears. His portrait was placed in the Academy.[1]

1. Lost

GIOVANNI PIETRO BELLORI

Michelangelo da Caravaggio

from

Le vite de' pittori, scultori e architetti moderni

1672

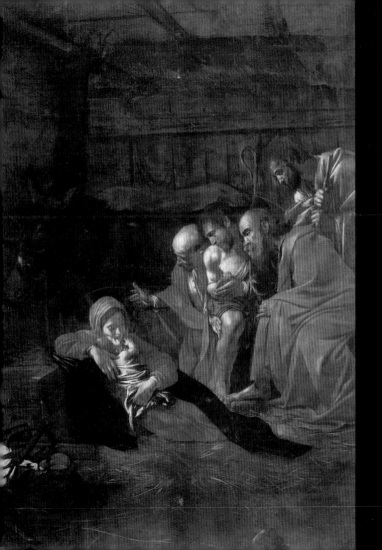

It is said that the ancient sculptor Demetrios was such a student of life that he preferred imitation to the beauty of things; we saw the same thing in Michelangelo Merisi, who recognized no other master than the model, without selecting from the best forms of nature — and what is incredible, it seems that he imitated art without art. With his birth he doubled the fame of Caravaggio, a notable town of Lombardy, which had also been the home of the celebrated painter Polidoro. Both artists began as masons and carried hods of mortar for construction. Since Michele was employed in Milan with his father, a mason, it happened that he prepared glue for some painters who were painting frescoes and, led on by the desire to paint, he remained with them, applying himself totally to painting. He continued in this activity for four or five years, making portraits, and afterward, being disturbed and contentious, because of certain quarrels he fled from Milan to Venice, where he came to enjoy the colours of Giorgione, which he then imitated. For this reason his first works are agreeably sweet, direct, and without those shadows that he used later on; and since of all the Venetian colourists Giorgione was the purest

Opposite: The Messina Nativity, 1609

and simplest in representing natural forms with only a few tones, Michele painted in the same manner when he was first studying nature intently. He went to Rome, where he lived without lodgings and without provisions; since models, without which he did not know how to paint, were too expensive, he did not earn enough to pay his expenses. Michele was therefore forced by necessity to work for Cavaliere Giuseppe d'Arpino, who had him paint flowers and fruit, which he imitated so well that from then on they began to attain that greater beauty that we love today. He painted a vase of flowers with the transparencies of the water and glass and the reflections of a window of the room, rendering flowers sprinkled with the freshest dewdrops;[1] and he painted other excellent pictures of similar imitations. But he worked reluctantly at these things and felt deeper regret at not being able to paint figures. When he met Prospero, a painter of grotesques, he took the opportunity to leave Giuseppe in order to compete with him for the glory of painting. Then he began to paint according to his own inclinations; not only ignoring but even despising the superb statuary of

1. Lost; but reminiscent of the still lives in the St Petersburg *Lute Player* and in the London *Boy Bitten by a Lizard*, ill. p. 44

antiquity and the famous paintings of Raphael, he considered nature to be the only subject fit for his brush. As a result, when he was shown the most famous statues of Phidias and Glykon in order that he might use them as models, his only answer was to point toward a crowd of people, saying that nature had given him an abundance of masters. And to give authority to his words, he called a gypsy who happened to pass by on the street and, taking her to his lodgings, he portrayed her in the act of predicting the future, as is the custom of these Egyptian women. He painted a young man who places his gloved hand on his sword and offers the other hand bare to her, which she holds and examines;[1] and in these two half-figures Michele captured the truth so purely as to confirm his beliefs. A similar story is told about the ancient painter Eupompos — though this is not the time to discuss to what extent such teachings are praiseworthy. Since Caravaggio aspired only to the glory of colour, so that the complexion, skin, blood and natural surfaces might appear real, he directed his eye and work solely to that end, leaving aside all the other aspects of art. Therefore, in order to find

1. 1593, Musei Capitolini, Rome, ill. pp. 12-13. Another autograph version in the Louvre is probably later.

figure types and to compose them, when he came upon someone in town who pleased him he made no attempt to improve on the creations of Nature. He painted a girl drying her hair, seated on a little chair with her hands in her lap. He portrayed her in a room, adding a small ointment jar, jewels and gems on the floor, pretending that she is the Magdalen.[1] She holds her head a little to one side, and her cheek, neck and breast are rendered in pure, simple, and true colours, enhanced by the simplicity of the whole figure, with her arms covered by a blouse and her yellow gown drawn up to her knees over a white underskirt of flowered damask. We have described this figure in detail in order to show his naturalistic style and the way in which he imitates truthful colouring by using only a few hues. On a bigger canvas he painted the Madonna resting on the Flight into Egypt;[2] here there is a standing angel who plays the violin, and St Joseph, seated, holds a book of music open for him; the angel is very beautiful, and by turning his head in sweet profile, displays his winged shoulders and the rest of his nude body, which is covered by a

1. Galleria Doria-Pamphilj, Rome, *c.* 1597, ill. opposite 2. Galleria Doria-Pamphilj, Rome, *c.* 1597, ill. p. 33

Opposite: The Penitent Magdalen, c. 1597

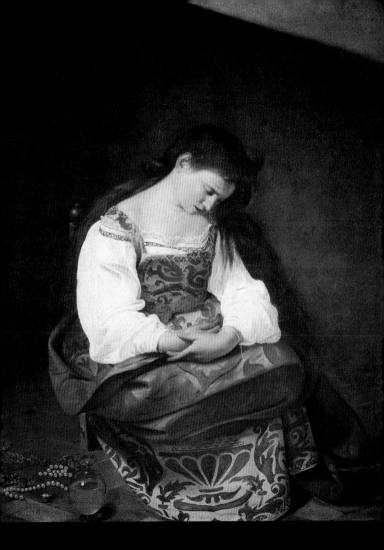

little drapery. On the other side sits the Madonna, who, with her head inclined, seems asleep with her baby at her breast. These pictures are in the palace of Prince Pamphili; and another one worthy of similar praise is in the rooms of Cardinal Antonio Barberini, which shows three half-figures playing cards.[1] He showed a simple young man holding the cards, his head portrayed well from life and wearing dark clothes, and on the opposite side there is a dishonest youth in profile, who leans on the card table with one hand while with the other behind him he slips a false card from his belt; a third man close to the young one looks at his cards and with three fingers reveals them to his companion who, as he bends forward over the small table, exposes the shoulder of his heavy yellow coat striped with black to the light. The colour is true to life. These are the first strokes from Michele's brush in the free manner of Giorgione, with tempered shadows. Prospero [Orsi, 'delle Grottesche'], by acclaiming the new style of Michele, increased the value of his works to his own advantage among the most important people of the court. The Cardsharps was bought by Cardinal Del Monte who, being a lover of paintings, set Michele

1. *c.* 1595, Kimbell Art Museum, Fort Worth, ill. opposite

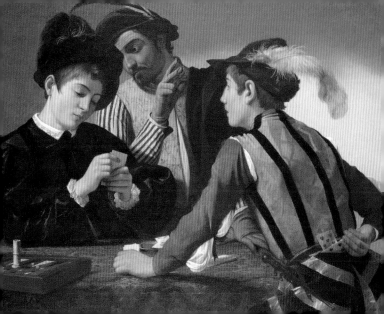

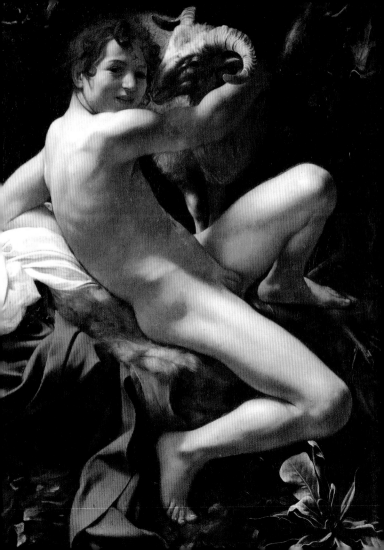

up and gave him an honoured place in his household. For this gentleman he painted the Concert of Youths portrayed from life in half-figures;[1] a woman in a blouse playing a lute with the music sheet in front of her;[2] a kneeling St Catherine leaning on the wheel.[3] The last two paintings are also in the same rooms but have a darker colour, as Michele had already begun to darken the darks. He painted St John in the desert,[4] a naked young boy, seated, who thrusts his head forward embracing a lamb; this painting can be seen in the palace of Cardinal Pio. But Caravaggio (as he was called by everyone, with the name of his native town) was becoming more famous every day because the colouring he was introducing was not as sweet and delicate as before, but became boldly dark and black, which he used abundantly to give relief to the forms. He went so far in this style that he never showed any of his figures in open daylight, but instead found a way to place them in the darkness of a closed room, placing a lamp high so that the light would fall straight down, revealing the principal part

1. c. 1595, Metropolitan Museum of Art, New York, ill. p. 47 2. Lost
3. 1598-99, Museo Thyssen-Bornemisza, Madrid, ill. p. 4 4. 1602,
Musei Capitolini, Rome, ill. opposite

Opposite: St John the Baptist, 1602

of the body and leaving the rest in shadow so as to produce a powerful contrast of light and dark. The painters then in Rome were greatly taken by this novelty, and the young ones particularly gathered around him, praised him as the unique imitator of nature, and looked on his work as miracles. They outdid each other in imitating his works, undressing their models and raising their lights. Without devoting themselves to study and instruction, each one easily found in the piazza and in the street their masters and the models for imitating nature. With this easy style attracting the others, only the older painters already set in their styles were dismayed by this new study of nature: they never stopped attacking Caravaggio and his style, saying that he did not know how to come out of the cellar and that, lacking *invenzione* and *disegno*, without decorum or art, he painted all his figures with a single source of light and on one plane without any diminution; but such accusations did not stop the flight of his fame.

Caravaggio painted the portrait of Cavaliere Marino,[1] with the reward of praise from literary men; the names of both the painter and the poet were sung in Academies; in fact Marino in particular so praised

1. Possibly identifiable with a painting in a private collection, London

the head of Medusa[1] by Caravaggio that Cardinal Del Monte gave it to the Grand Duke of Tuscany. Because of his kindness and his delight in Caravaggio's style, Marino introduced the painter into the house of Monsignor Melchiorre Crescenzi, clerk of the papal chamber. Michele painted the portrait of this most learned prelate[2] and another of Virgilio Crescenzi[3] who, as heir of Cardinal Contarelli, chose him to compete with Giuseppino [Cesari d'Arpino] for the paintings in the chapel of San Luigi dei Francesi. Marino, who was the friend of both painters, suggested that Giuseppe, an expert fresco painter, be given the figures on the wall above and Michele the oil paintings. Here something happened that greatly upset Caravaggio with respect to his reputation. After he had finished the central picture of St Matthew and installed it on the altar,[4] the priests took it down, saying that the figure with its legs crossed and its feet rudely exposed to the public had neither decorum nor the appearance of a saint. Caravaggio was in despair at such an outrage over his first work in a church, when Marchese Vincenzo Giustiniani acted in his favour and freed him from

1. 1597, Uffizi, Florence, ill. p. 1 2. Lost 3. Lost 4. 1602, destroyed: formerly Kaiser-Friedrich Museum, Berlin, ill. overleaf

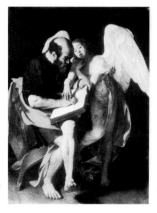

*St Matthew and the Angel:
first version (1602), left;
second version (1602), opposite*

this predicament. So, intervening with the priests, he took the painting for himself and had Caravaggio do a different one, which is now to be seen above the altar. And to honour the first painting more he took it to his house and later added the other three Evangelists by Guido [Reni], Domenichino, and Albani, three of the most famous painters of that time. Caravaggio used all his powers to succeed in his second picture; and in order to give a natural form to the saint writing the gospel, he showed him with a knee bent over the stool and his hands on the table, in the act of dipping his pen in the inkwell above the book. In so doing he turns his face from the left

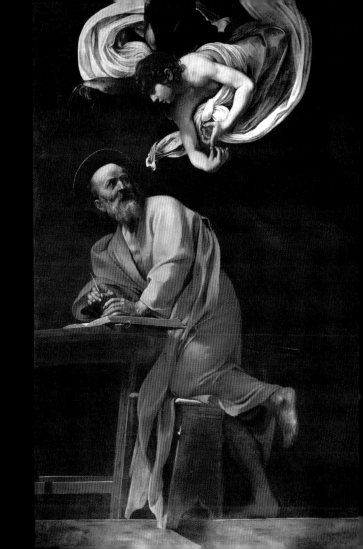

towards the angel who, suspended on his wings in air, talks to him and makes a sign by touching the index finger of his left hand with his right. The colouring makes the angel seem far away, suspended on his wings towards the saint, his arms and chest naked and the white fluttering veil surrounding him in the background darkness. Christ Calling St Matthew to the Apostolate[1] is on the right side of the altar. He portrayed several heads from life, among them the saint's, who, stopping to count the coins, with one hand on his chest turns towards the Lord. Close to him an old man is putting his eyeglasses on his nose, looking at a young man seated at the corner of the table who draws the coins to himself. On the other side there is the Martyrdom of the saint[2] himself, who is dressed in priestly garments stretched out on a bench. The nude figure of the executioner is brandishing his sword in the act of wounding him while the others withdraw in horror. The composition and movements in the painting, however, are insufficient for the narrative, though he did it over twice. These two paintings are difficult to see because of the darkness in the chapel and because of their colour. He then painted the picture

1. 1599-1600, in situ, ill. p. 17 2. 1599-1600, in situ, ill. opposite

Opposite: The Martyrdom of St Matthew, 1599-1600

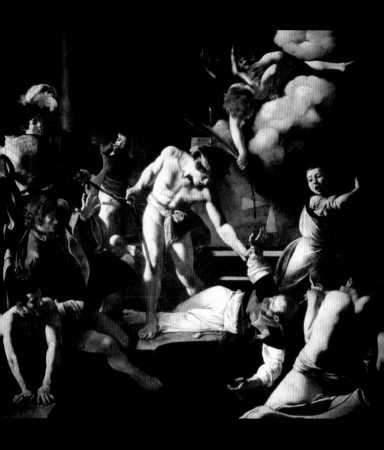

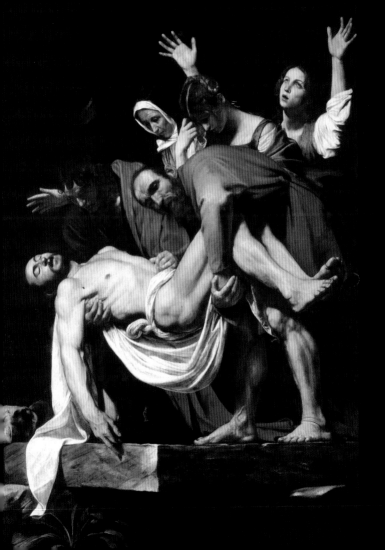

of the Cavalletti chapel in the church of Sant'
Agostino, with the standing Madonna holding the
Child in her arms in the act of giving benediction:
two pilgrims with clasped hands are kneeling before
her, the first one a poor man with feet and legs bare,
with a leather cape and a staff resting on his shoulder.
He is accompanied by an old woman with a cap on
her head.[1]

People correctly hold in great esteem the
Deposition of Christ[2] in the Chiesa Nuova of the
Oratorians, one of the finest works of Michele's
brush. The figures are located on a slab at the open-
ing of the sepulchre. In the middle we see the holy
body. The standing Nicodemus holds it under the
knees; in lowering the hips the legs jut out. On the
other side St John holds one arm under the
Redeemer's shoulder, whose face is turned up and his
chest deadly pale as one arm hangs down with the
sheet: the nude parts are portrayed with the force of
the most exacting naturalism. Behind Nicodemus we
see the mourning Maries; one has her arms raised,
another has a veil over her eyes, and the third looks

1. 1604-5, in situ; ill. p. 51, also known as the *Madonna of Loreto*
2. Also called *Entombment*, 1602-3, Vatican Museums; ill. opposite

Opposite: The Entombment of Christ, 1602-3

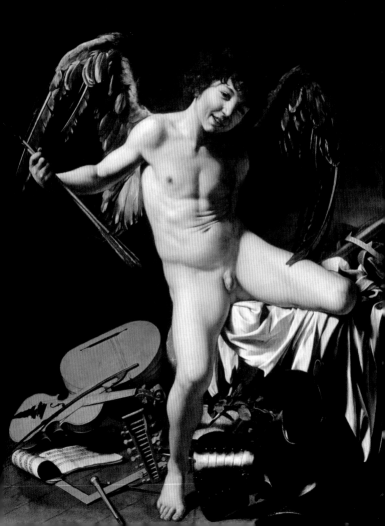

at the Lord. In the church of the Madonna del
Popolo, inside the chapel of the Assumption painted
by Annibale Carracci, the two pictures on the sides
are by Caravaggio: the Crucifixion of St Peter[1] and
the Conversion of St Paul,[2] in which the history is
completely without action. He continued to be
favoured by Marchese Vincenzo Giustiniani, who
commissioned various pictures such as the Crowning
with Thorns[3] and St Thomas[4] putting his finger into
the wound in the Lord's side. Christ holds St
Thomas's hand and exposes his chest from the
shroud. In addition to these half-figures he painted
the Victorious Love with an arrow raised in his right
hand while arms, books, and various trophies lie
about on the ground at his feet.[5] Other Roman gen-
tlemen vied with each other in admiring his works,
and among them, Marchese Asdrubale Mattei, for
whom he painted the Taking of Christ in the
Garden,[6] also in half-figures. Judas is shown after the

1. 1600-1601, in situ 2. 1600-1601, in situ, ill. p. 30 3. *c.* 1605,
Kunsthistoriches Museum, Vienna 4. 1601-2, Staatliche Schlösser
& Gärten, Potsdam 5. *c.* 1602, Gemäldegalerie, Berlin, ill. opposite
6. 1602, National Gallery, Dublin, ill. overleaf

Opposite: Victorious Love, 1601-2

Overleaf: The Taking of Christ in the Garden, 1602

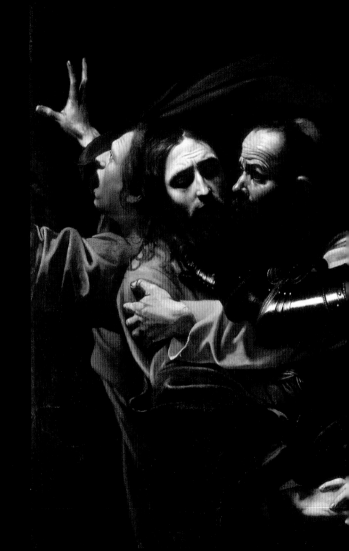

kiss with his hand on the Lord's shoulder; a soldier in full armour extends his arms and his ironclad hand towards the chest of the Lord, who stands still, patiently and humbly, his hands crossed before him, as John runs away behind with outstretched arms. Caravaggio rendered the rusty armour of the soldier accurately with head and face covered by a helmet, his profile partially visible. Behind him a lantern is raised and we see the heads of two other armed men. For the Massimi he painted an Ecce Homo[1] that was taken to Spain; for the Marchese Patrizi he painted the Supper at Emmaus,[2] with Christ in the centre in the act of blessing the bread: one of the two seated Apostles extends his arms as he recognizes the Lord and the other one places his hands on the table and looks at him with astonishment. Behind are the innkeeper with a cap on his head and an old woman who brings food. He painted a quite different version[3] for Cardinal Scipione Borghese; the first one is darker, but both are to be praised for their natural colours even though they lack decorum, since Michele's work often degenerated into common and vulgar forms. For the same cardinal Caravaggio

1. 1605, possibly identifiable with painting in Cassa di Risparmio di Prato 2. 1606, Pinacoteca di Brera, Milan 3. 1601, National Gallery, London

painted St Jerome,[1] who is shown writing attentively and extending his hand to dip his pen into an inkwell; and another painting, the half-figure of David,[2] who holds the head of Goliath by the hair, which is his own portrait. He holds the sword and is shown as a bareheaded youth with one shoulder emerging from his shirt; it is painted with the deep dark shadows that Caravaggio liked to use in order to give strength to his figures and compositions. The cardinal, pleased with these and other works, introduced Caravaggio to Pope Paul V, whom he portrayed seated[3] and by whom he was well rewarded. For Cardinal Maffeo Barberini, who became Pope Urban VIII, in addition to a portrait,[4] he painted the Sacrifice of Abraham,[5] in which Abraham holds a knife to the throat of his son, who screams and falls.

But Caravaggio's preoccupation with painting did not calm his restless nature. After having painted for a few hours in the day he used to go out on the town with his sword at this side like a professional swordsman, seeming to do anything but paint. And during a

1. *c.* 1605, Galleria Borghese, Rome, ill. overleaf 2. *c.* 1610, Galleria Borghese, Rome, ill. p. 24 3. Possibly a painting in Palazzo Borghese, Rome 4. Probably a painting in a private collection, Florence 5. *c.* 1602, Uffizi, Florence

Overleaf: St Jerome Writing, c. 1605

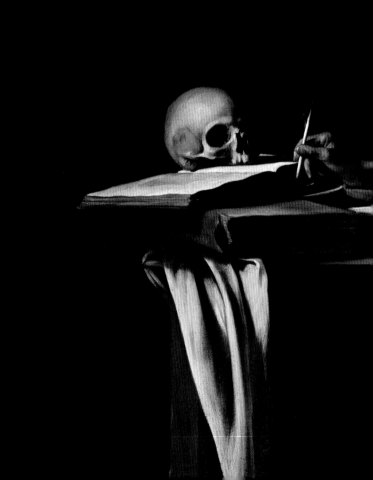

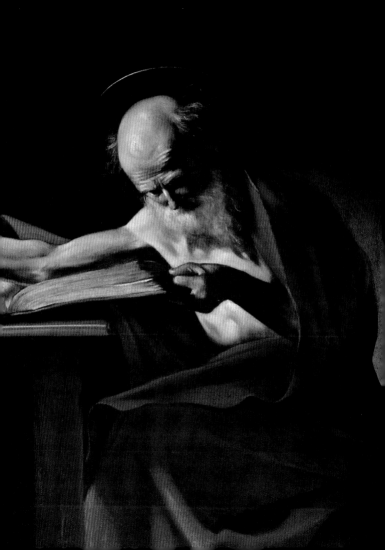

tennis match with a young friend of his, they began hitting each other with their rackets. At the end he drew his sword, killed the young man, and was also wounded himself. Fleeing from Rome, without money and being followed, he found refuge in Zagarolo under the protection of Duke Marzio Colonna, where he painted Christ in Emmaus between the Apostles[1] and another half-figure of the Magdalen.[2] Afterwards he went to Naples, where he immediately found employment, since his style and reputation were already known there. He was commissioned to do the Flagellation of Christ at the Column[3] in the Di Franco Chapel of the church of San Domenico Maggiore. In Sant'Anna de' Lombardi he painted the Resurrection.[4] In Naples, the Denial of St Peter[5] for the Sacristy of San Martino is thought to be among his finest works. It shows a servant girl pointing at Peter, who turns around with open hands in the act of denying Christ; it is a nocturnal scene with other figures warming themselves at the fire. In the same city

1. Probably the version in the Pinacoteca di Brera, Milan, ill. p. 36 2. Lost 3. 1607, Museo Nazionale di Capodimonte, Naples, ill. opposite 4. Possibly identifiable with painting in Kunsthistorisches Museum, Vienna 5. 1607, lost; a painting of this subject survives in the Sacristy

Opposite: The Flagellation of Christ, 1607

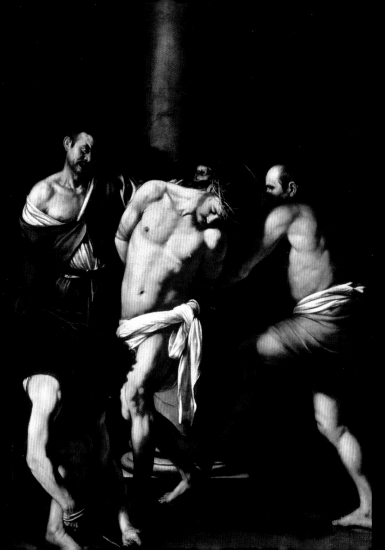

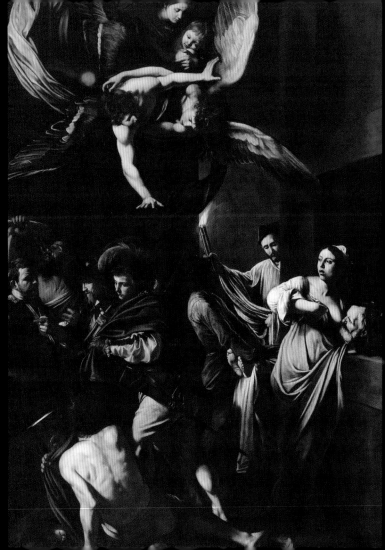

for the church of the Misericordia he painted the Seven Acts of Mercy,[1] a picture about ten *palmi* high; one sees the head of an old man sticking out through the bars of a prison, sucking milk from the bare breast of a woman bending down towards him. Among the other figures you can distinguish the feet and legs of a corpse carried to burial; and the rays from the light of the torch held by one of the men who bears the body spread over the priest with a white surplice, revealing the colour and giving life to the composition.

Caravaggio was eager to receive the Cross of Malta, which is usually given *per grazia* to honoured men for their merit and virtue. He decided to go to that island, where he was introduced to the Grand Master Wignacourt, a French gentleman. He painted him standing dressed in armour[2] and seated without armour,[3] in the habit of Grand Master; the first is in the Armoury of Malta. The Master rewarded Caravaggio with the Cross. In the church of San Giovanni he was ordered to paint the Beheading of St John, who has fallen to the ground while the executioner, almost as if he had not killed him with his

1. 1606-7, Pio Monte della Misericordia, Naples, ill. opposite 2. *c.* 1607, Louvre, Paris, ill. overleaf 3. Lost

Opposite: The Seven Acts of Mercy, 1606-7

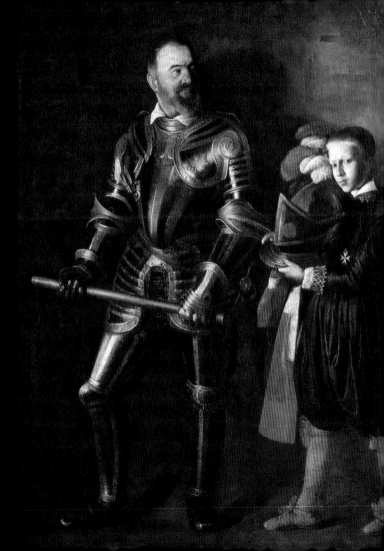

sword, takes his knife from his side, seizing the saint by his hair in order to cut off his head.[1] Herodias looks on intently, and an old woman is horrified by the spectacle, while the prison warder, dressed in a Turkish garment, points to the atrocious slaughter. In this work Caravaggio put all the force of his brush to use, working with such intensity that he let the priming of the canvas show through the half-tones. As a reward, beside the honour of the Cross, the Grand Master put a gold chain around Caravaggio's neck, and made him a gift of two slaves, along with other signs of esteem and appreciation for his work. For the same church of San Giovanni, in the Italian Chapel, he painted two half-figures over two doors, the Magdalen[2] and St Jerome in the act of writing.[3] He painted another St Jerome with a skull,[4] in meditation on death, which is still in the palace. Caravaggio was very happy to have been honoured with the Cross and for the praise received for his paintings. He lived in Malta in dignity and abundance. But suddenly, because of his tormented nature, he lost his prosperity

1. 1607, Valletta, Oratory of the Co-Cathedral of St John, ill. pp. 22-23. Only signed painting to survive 2. Lost 3. *c.* 1608, Museum of Co-Cathedral of St. John the Baptist, Valletta 4. Lost

Opposite: Grand Master Alof de Wignacourt and his page, c. 1608

and the support of the Grand Master. On account of an ill-considered quarrel with a noble knight, he was jailed and reduced to a state of misery and fear. In order to free himself he was exposed to grave danger, but he managed to scale the prison walls at night and to flee unrecognized to Sicily, with such speed that no one could catch him. In Syracuse he painted the altarpiece[1] for the church of Santa Lucia in the port outside the city. He painted the dead St Lucy blessed by the bishop; there are also two men who dig her grave with shovels. He then went to Messina, where he painted the Nativity[2] for the Capuchin Fathers. It represents the Virgin and Child before a broken-down shack with its boards and rafters apart. St Joseph leans on his staff, with some shepherds in adoration. For the same Fathers he painted St Jerome,[3] who is writing in a book, and in the Lazari Chapel, in the church of the Ministri degl'Inferni, he painted the Resurrection of Lazarus[4] who, being raised from the sepulchre, opens his arms as he hears the voice of Christ who calls him and extends his hand towards

1. 1608, Museo Nazionale, Syracuse 2. 1609, Museo Nazionale, Messina, ill. p. 62 3. Lost 4. 1609, Museo Nazionale, Messina, ill. opposite

Opposite: The Resurrection of Lazarus, 1609

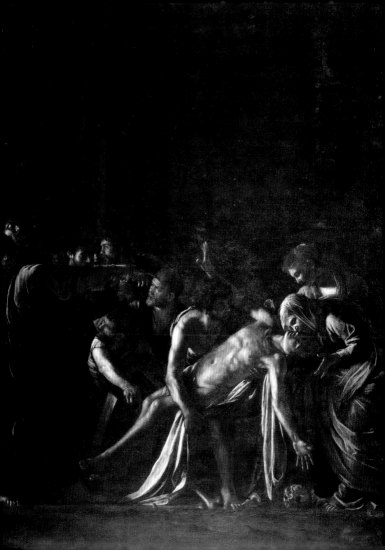

him. Martha is crying and the Magdalen appears astonished, and there is a figure who puts his hand to his nose to protect himself from the stink of the corpse. The painting is huge, and the figures are in a grotto with brilliant light on the nude body of Lazarus and those who support him. This painting is very highly esteemed for its powerful realism. But misfortune did not abandon Michele, and fear hunted him from place to place. Consequently he hurried across Sicily and from Messina went to Palermo, where he painted another Nativity for the Oratorio of San Lorenzo.[1] The Virgin is shown adoring her newborn child, with St Francis, St Lawrence, the seated St Joseph, and above an angel in the air. The lights are diffused among shadows in the darkness.

After this he no longer felt safe in Sicily, and so he departed the island and sailed back to Naples, where he thought he would stay until he got word of his pardon allowing him to return to Rome. And hoping to placate the Grand Master, Caravaggio sent to him as a present a half-figure of Herodias with the head of St John the Baptist in a basin.[2] These efforts did not succeed. Indeed, one day at the doorway of the

1. 1609, in situ until stolen on 17 October 1969 2. Possibly the version in the Palacio Real, Madrid, or the one in the National Gallery, London, ill. p. 98-99

Osteria del Citiglio he was surrounded by armed men who attacked him and wounded him in the face. Thus, as soon as possible, although suffering the fiercest pain, he boarded a felucca and headed for Rome, having by then obtained his freedom from the Pope through the intercession of Cardinal Gonzaga. Upon his arrival ashore, a Spanish guard, who was waiting for another knight, arrested him by mistake, holding him prisoner. And when he was finally released he never again saw his felucca or his possessions. Thus, in a miserable state of anxiety and desperation, he ran along the beach in the heat of the summer sun. Arriving at Port'Ercole, he collapsed and was seized by a malignant fever that killed him in a few days, at about forty years of age, in 1609.* This was a sad year for painting, since Annibale Carracci and Federico Zuccaro also died. Thus Caravaggio ended his life on a deserted beach while in Rome people were enthusiastically waiting for his return. But the unexpected news of his death arrived in Rome and saddened everyone. His very good friend, Cavaliere Marino, mourned his death and honoured his funeral with the following verses:

* In fact 1610

Overleaf: Herodias with the head of St John the Baptist, c. 1610

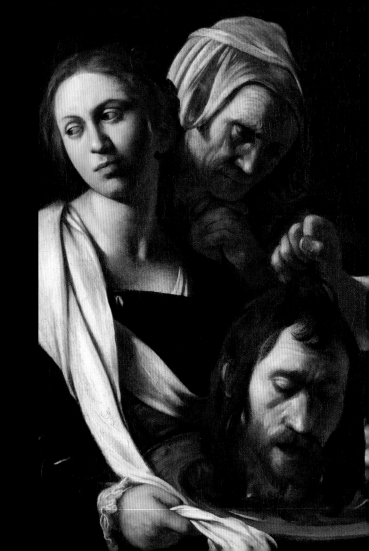

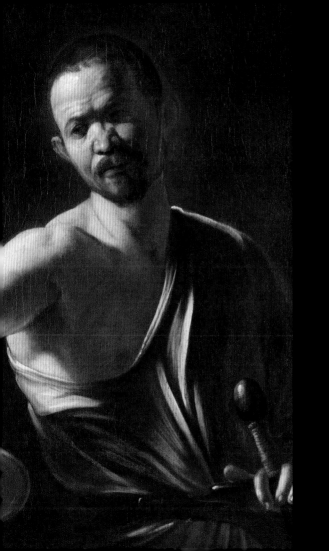

Death and Nature made a cruel plot against you, Michele:
Nature was afraid
Your hand would surpass it in every image:
You created, not painted.
Death burned with indignation,
Because however many more
His scythe would cut down in life,
Your brush recreated even more.

Without doubt Caravaggio advanced the art of painting, for he lived at a time when realism was not much in vogue and figures were made according to convention and *maniera*, satisfying more a taste for beauty than for truth. Thus by avoiding all pettiness and falsity in his colour, he strengthened his hues, giving them blood and flesh again, thereby reminding painters to work from nature. Consequently, Caravaggio did not use cinnabar reds or azure blues in his figures; and if he occasionally did use them, he toned them down, saying that they were poisonous colours. He never used clear blue atmosphere in his pictures; indeed, he always used a black ground, and black in his flesh tones, limiting the highlights to a few areas. Moreover, he claimed that he imitated his models so closely that he never made a single brushstroke that he called his own, but said rather that it was nature's.

Repudiating all other rules, he considered the highest achievement not to be bound to art. For this innovation he was greatly acclaimed, and many talented and educated artists seemed compelled to follow him, as is the case of Guido Reni, who adopted much of his manner and demonstrated himself a realist, as we see in the Crucifixion of St Peter in the Tre Fontane; and so did also Giovan Francesco [Guercino] da Cento. Such praise caused Caravaggio to appreciate himself alone, and he claimed to be the only faithful imitator of nature. Nevertheless, he lacked *invenzione*, decorum, *disegno*, or any knowledge of the science of painting. The moment the model was taken from him, his hand and his mind became empty. Nonetheless many artists were taken by his style and gladly embraced it, since without any kind of effort it opened the way to easy copying, imitating common forms lacking beauty. Thus, as Caravaggio suppressed the dignity of art, everybody did as he pleased, and what followed was contempt for beautiful things, the authority of antiquity and Raphael destroyed. Since it was easy to find models and to paint heads from life, giving up the history painting appropriate for artists, these people made half-figures, which were previously uncommon. Now began the imitation of common and vulgar things, seeking out filth and deformity, as some

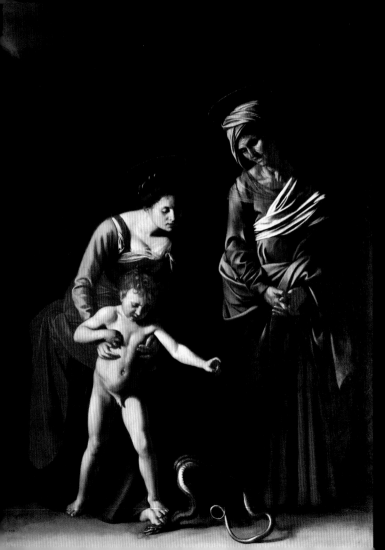

popular artists do assiduously. So if they have to paint armour, they choose to reproduce the rustiest; if a vase, they would not complete it except to show it broken and without a spout. The costumes they paint consist of stockings, breeches, and big caps, and in their figures they pay attention only to wrinkles, defects of the skin and exterior, depicting knotted fingers and limbs disfigured by disease.

Because of his style Caravaggio encountered dissatisfaction, and some of his paintings were taken down from their altars, as we saw in the case of San Luigi. The same thing happened to his Death of the Virgin in the Chiesa della Scala, which was removed because he had shown the swollen body of a dead woman too realistically. The other picture, of St Anne, was also removed from one of the minor altars of Saint Peter's because of the offensive portrayal of the Virgin with the nude Christ child, as we can see in the Villa Borghese. In Sant'Agostino we are presented with the filthy feet of the pilgrim; in Naples, in the picture of the Seven Works of Mercy, a man depicted raising his flask in the act of drinking, with his mouth wide open as the wine flows coarsely into it. In the Supper at Emmaus, in addition to the vulgar conception of the two Apostles and of the Lord who is

Opposite: Madonna and Child with St Anne, 1605-6

shown young and without a beard, the innkeeper wears a cap, and on the table is a dish of grapes, figs and pomegranates out of season. Just as certain herbs produce both beneficial medicine and most pernicious poison, in the same way, though he produced some good, Caravaggio has been most harmful and wrought havoc with every ornament and good tradition of painting. It is true that painters who strayed too far from nature needed someone to set them on the right path again — but how easy it is to fall into one extreme while fleeing from another. By departing from the *maniera* in order to follow nature too closely, they moved away from art altogether and remained in error and darkness until Annibale Carracci came to enlighten their minds and restore beauty to the imagination of nature.

Caravaggio's style corresponded to his physiognomy and appearance; he had a dark complexion and dark eyes, and his eyebrows and hair were black; this colouring was naturally reflected in his paintings. His first style, sweet and pure in colour, was his best; he made great achievement in it and proved that he was a most excellent Lombard colourist. But afterward, driven by his own nature, he retreated to the dark style

Opposite: The Crucifixion of St Andrew, 1607

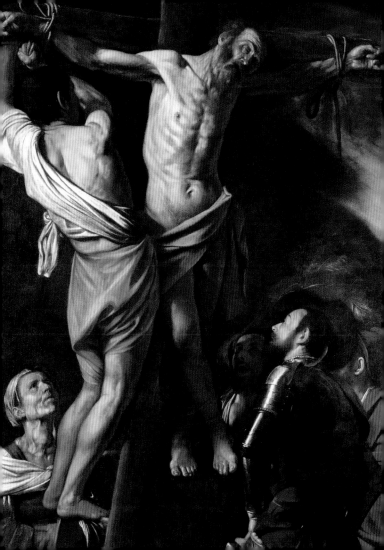

that is connected to his disturbed and contentious temperament. At first he had to flee Milan and then his homeland; then he was compelled to flee from Rome and Malta, to hide in Sicily, to be in danger in Naples, and finally to die miserably on a beach. We cannot fail to mention his behaviour and his choice of clothes, since he wore only the finest materials and princely velvets; but once he put on a suit of clothes he changed only when it had fallen to rags. He was very negligent in washing himself; for years he used the canvas of a portrait as a table cloth, morning and evening.

Caravaggio's colours are prized wherever art is valued. The painting of St Sebastian[1] with his hands tied behind his back by two executioners, one of his best works, was taken to Paris. The Count of Benevento, who was Viceroy of Naples, took the Crucifixion of St Andrew[2] to Spain; the Count of Villamediana owned the half-figure of David[3] and the portrait of a Youth with an Orange Blossom in his hand.[4] In the church of the Dominicans in Antwerp is the painting of the Rosary,[5] which brought great praise to

1. Lost 2. 1607; Cleveland Museum of Art, ill. p. 105 3. Lost 4. Lost
5. *c.* 1607, Kunsthistorisches Museum, Vienna, ill. opposite

Opposite: Madonna of the Rosary, c. 1607

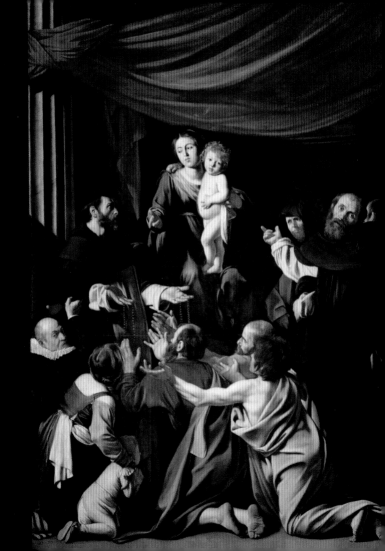

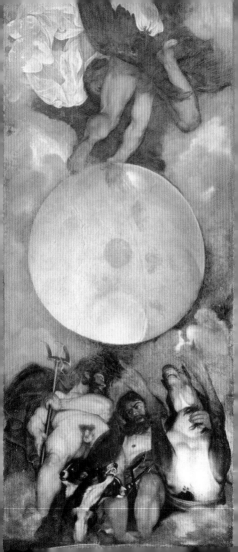

Caravaggio. In Rome in the Ludovisi Gardens near the Porta Pinciana, they attribute to Caravaggio the Jupiter, Neptune, and Pluto in the casino of Cardinal Del Monte,[1] who was interested in chemical medicines and adorned the small room of his laboratory, associating those gods with the elements and with the globe of the world placed in their midst. It has been said that Caravaggio, reproached for not understanding either planes or perspective, placed the figures in such a position that they appear to be seen from sharply below, so as to vie with the most difficult foreshortenings. It is indeed true that those gods do not retain their proper forms, and are painted in oil on the vault, since Michele had never painted in fresco; just as all his followers prefer the easy way of oil painting when portraying the model. Many were those who imitated his style of painting from nature and were therefore called naturalists. And among them we shall note some who gained a great name. [Here follow brief biographies of Manfredi, Saraceni, Ribera, Valentin, and van Honthorst.]

1. *c.* 1599, in situ, ill. opposite

Opposite: Jupiter, Neptune and Pluto, c. 1599

List of illustrations
All works oil on canvas unless stated otherwise

Illustrations on pp. 1, 2, 4, 10, 12-13, 14, 17, 18, 22-23, 24, 30, 33, 34, 36, 44, 51, 52,
54-55, 67, 69, 70, 74, 75, 77, 78, 80, 82-83, 86-87, 89, 90, 92, 95, 98-99, 102, 105,
107 and 108 courtesy of holding institutions/Google Art Project/Wikimedia; on
p. 6 courtesy of architas, Wikimedia; on pp. 47 and 58-59 courtesy Metropolitan
Museum of Art, New York; on pp. 62 courtesy Bridgeman, London

Published in the United States of America in 2019 by the J. Paul Getty Museum, Los Angeles
Getty Publications
1200 Getty Center Drive, Suite 500
Los Angeles, California 90049-1682
www.getty.edu/publications

Distributed in the United States and Canada by the University of Chicago Press

Printed in China

ISBN 978-1-60606-622-5

Library of Congress Control Number: 2019932014

Published in the United Kingdom by Pallas Athene (Publishers) Ltd
Studio 11A, Archway Studios
25–27 Bickerton Road, London N19 5JT

Alexander Fyjis-Walker, *Series Editor*
Anaïs Métais, *Editorial Assistant*

Front cover: Michelangelo Merisi da Caravaggio, *David with the Head of Goliath*, 1609–10 (detail, p. 24). Oil on canvas, 125 x 100 cm (49.2 x 39.3 in.). Galleria Borghese, Rome. Photo: Scala / Ministero per i Beni e le Attività culturali / Art Resource, NY

Note to the reader: The text of these three biographies is based on the translation published by Howard Hibbard in his *Caravaggio* (London, 1983). They were originally published as follows: Guilio Mancini's *Considerazioni sulla pittura* survives as a manuscript, and dates to between ca. 1617 and 1621. An edition by A. Marucchi was published in Rome in 1956–57. Hibbard organized passages of this text into a biography of Caravaggio, and included Mancini's characterization of the schools of Roman painting. Giovanni Baglione's *Le Vite de' pittori, scultori et architetti* was published in Rome in 1642. It had allegedly been reworked for publication by a literary man, Ottaviano Tronsarelli. Bellori's own annotated copy of Baglione's text survives. Giovanni Pietro Bellori was the Pope's official 'Antiquarian of Rome.' His *Le Vite de' pittori, scultori e architetti moderni* was first published in Rome in 1672, and remains a cornerstone text for the period. This translation is based on the edition prepared by Evelyn Borea and published in Turin in 1976.